A Keepsake

# PENNSYLVANIA'S
# COVERED BRIDGES

*Michael P. Gadomski*

SCHIFFER
PUBLISHING

4880 Lower Valley Road · Atglen, PA 19310

# INTRODUCTION

Pennsylvania can justifiably claim the title of "Covered Bridge Capital." According to the Pennsylvania Department of Transportation, the first covered bridge in the United States was constructed in 1800 over the Schuylkill River in Philadelphia, while the longest covered bridge ever constructed in the United States was 5,960 feet long, spanning the Susquehanna River between Lancaster and York counties. Sadly, it lasted only three years (1815—1818), destroyed by an ice jam. But in its time, it was an engineering marvel. At the peak of covered bridge construction during the nineteenth century, Pennsylvania claimed around 1,500 bridges. Today only a little more than 200 remain, yet this is more than any other state, and well over 20 percent of all covered bridges in the United States.

Thankfully today there is a growing interest in maintaining and preserving these romantic relics of a bygone age. The Commonwealth, local governments, and private organizations are all working together to preserve the remaining bridges, many of which are listed on the National Register of Historic Places.

Once known as "Kissing Bridges," their shaded, concealed interior provided a young man the perfect opportunity to steal a kiss from his sweetheart riding next to him in his horse-drawn buggy. Likely few young ladies objected.

Today visitors from around the world visit Pennsylvania to seek out its covered bridges, making them one of the state's important tourist attractions.

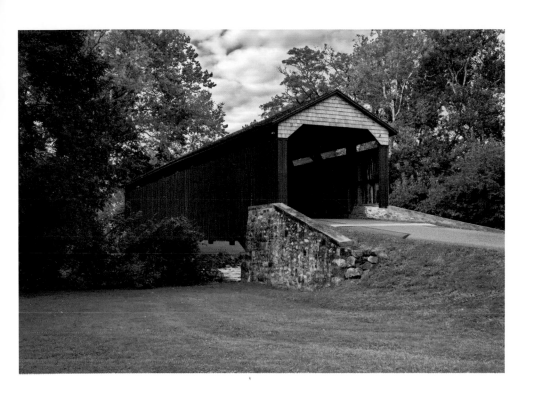

Poole Forge/Wimer Covered Bridge,
Lancaster County

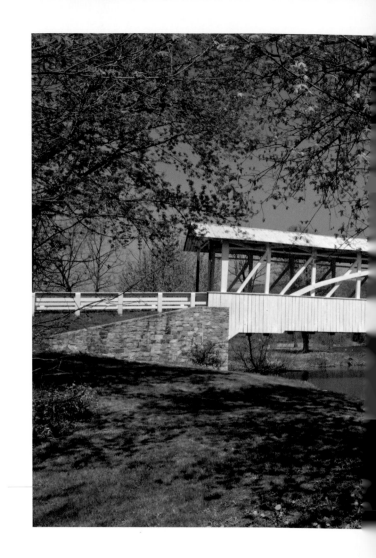

Hall's Mill Covered Bridge,
Bedford County

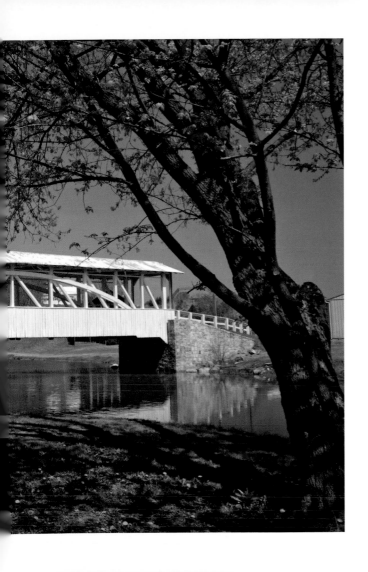

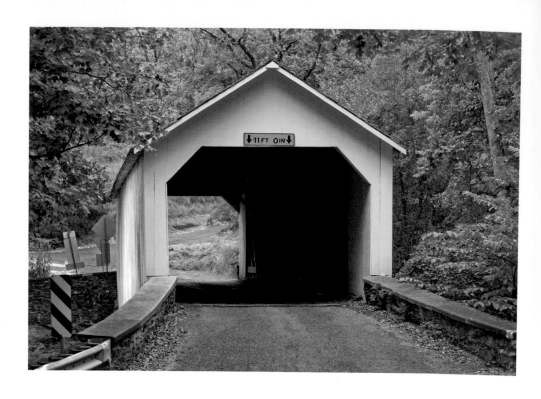

Loux/Loux Mill Ford Covered Bridge,
Bucks County

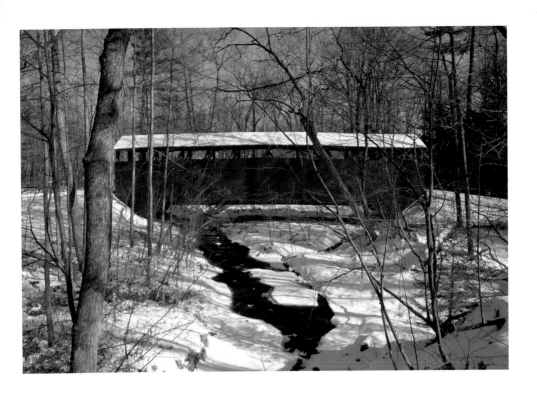

Clay's/Wahneta Covered Bridge,
Perry County

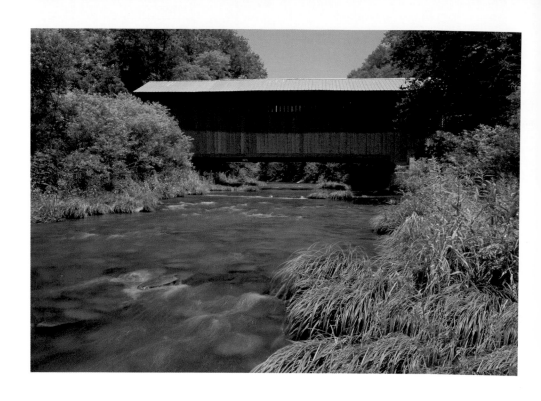

Sam Eckman's Covered Bridge,
Columbia County

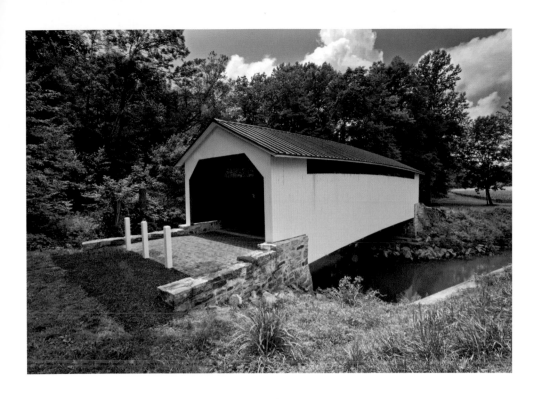

Henninger Farm/Stroup's Covered Bridge,
Dauphin County

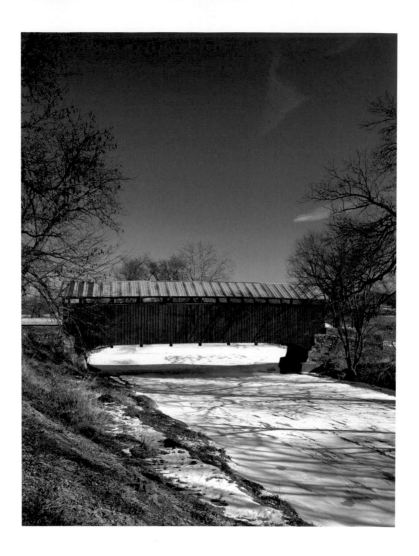

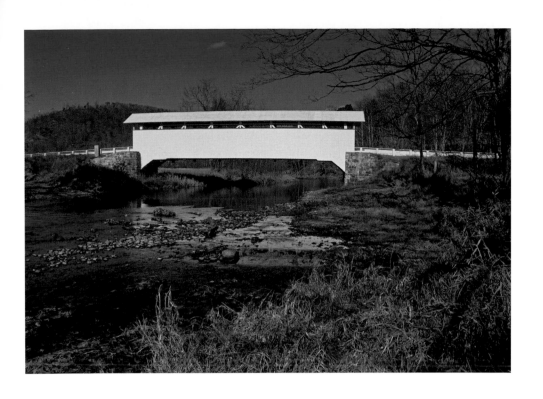

Sam Wagner/Gottlieb Brown Covered Bridge,
Montour/Northumberland Counties

Hewitt Covered Bridge,
Bedford County

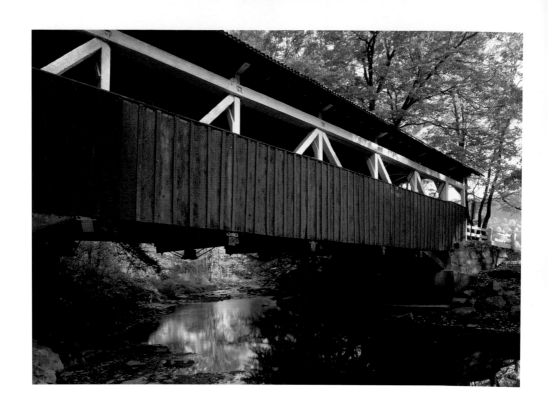

Shaffer's/Ben's Creek Covered Bridge,
Somerset County

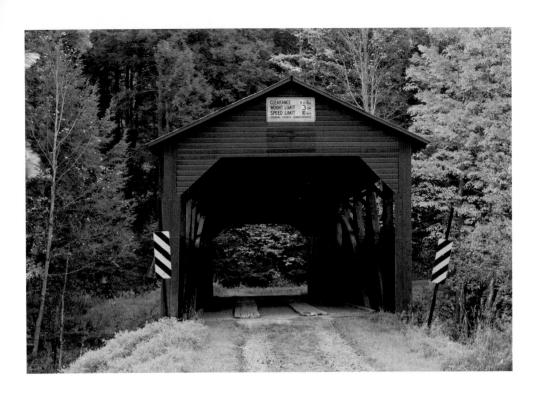

Cogan House/Buckhorn Covered Bridge,
Lycoming County

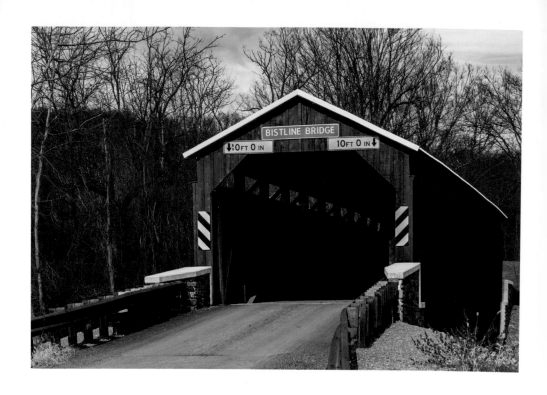

Bistline /Flickinger's Mill Covered Bridge,
Perry County

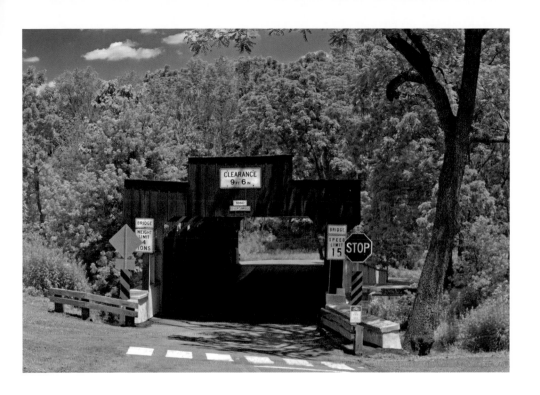

Geiger's Covered Bridge,
Lehigh County

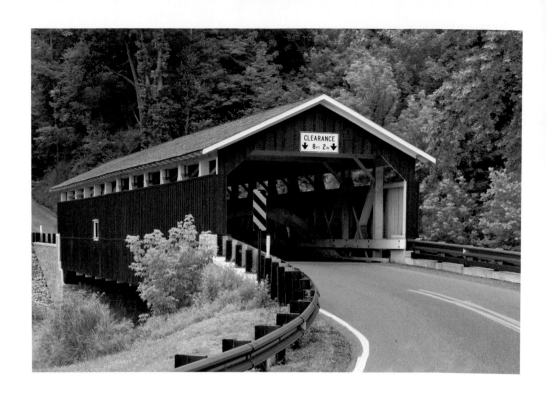

Schlicher's Covered Bridge,
Lehigh County

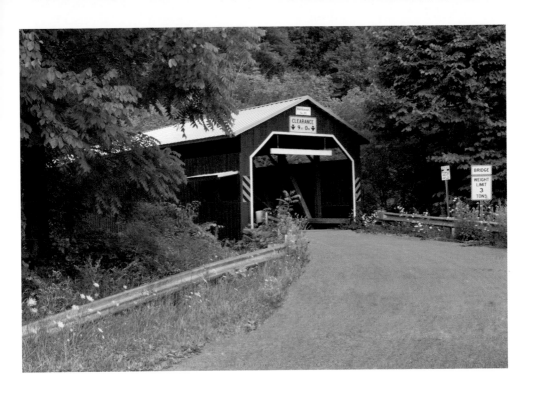

Patterson Bridge Covered Bridge,
Columbia County

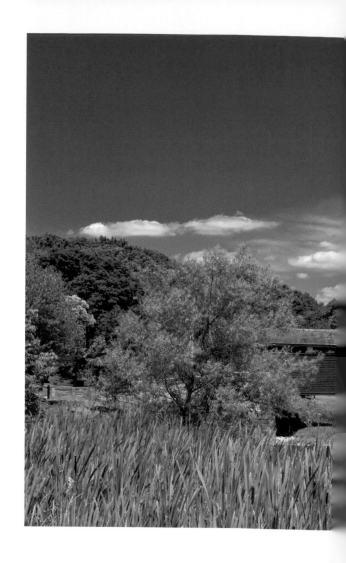

Wehr's Covered Bridge,
Lehigh County

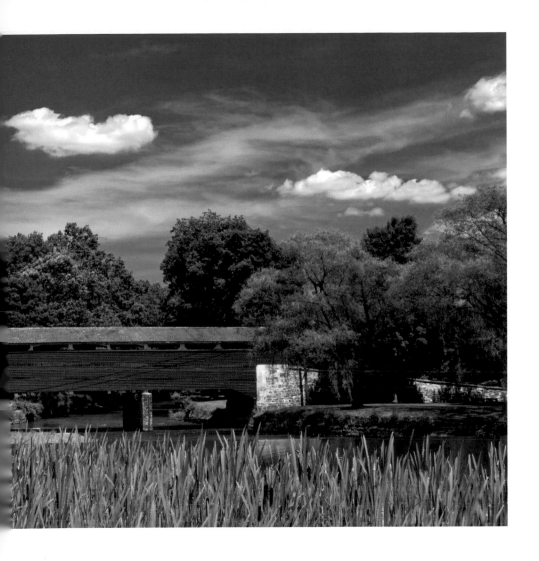

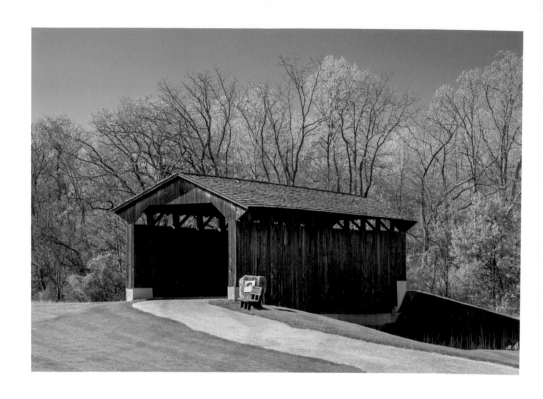

Larkin's Mill Covered Bridge,
Chester County

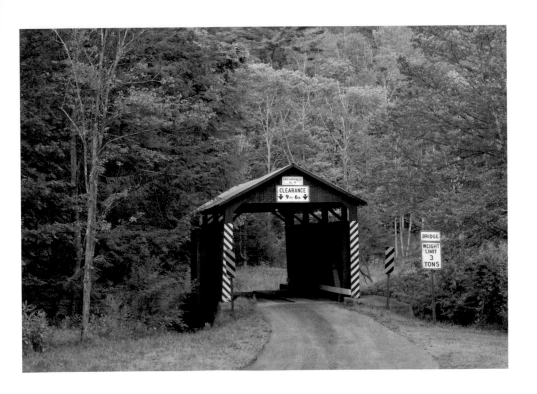

Creasyville Bridge Covered Bridge,
Columbia County

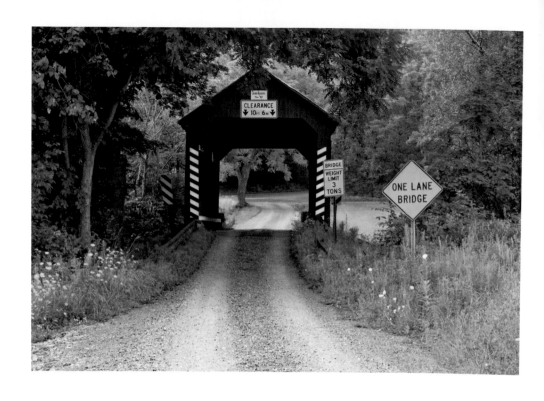

Johnson Covered Bridge,
Columbia County

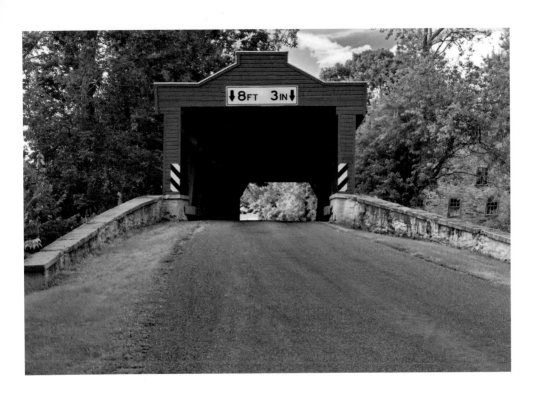

Kutz's Mill/Sacony Covered Bridge,
Berks County

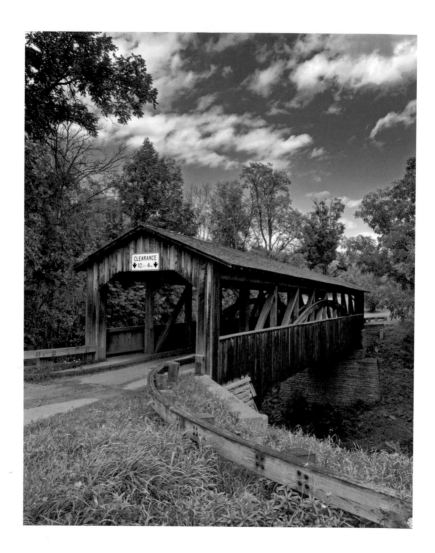

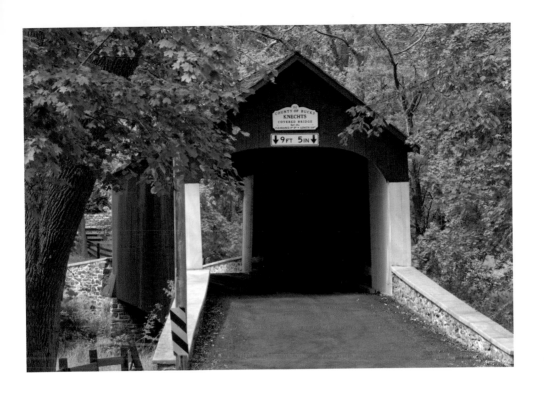

Luther Mills/Knapp's Covered Bridge,
Bradford County

Knecht's/Sleifer/Clymer's Covered Bridge,
Bucks County

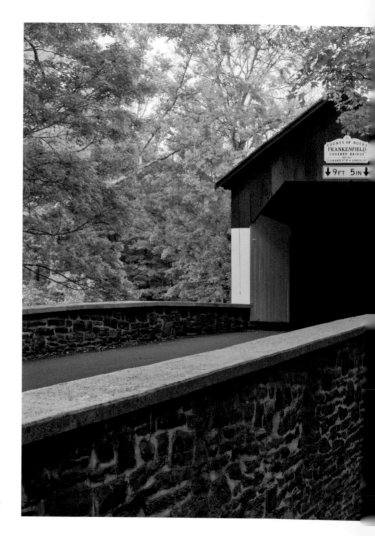

Frankenfield Covered Bridge,
Bucks County

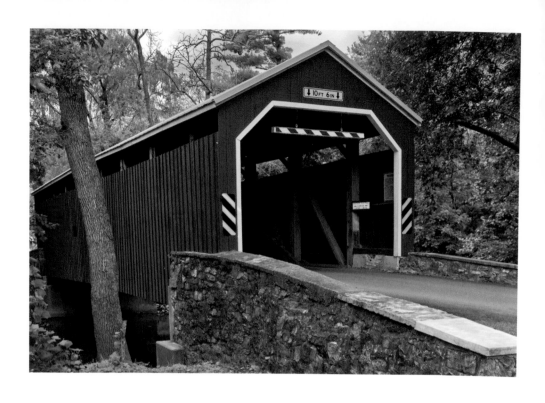

Zook's Mill/Rose Hill/Wenger Covered Bridge,
Lancaster County

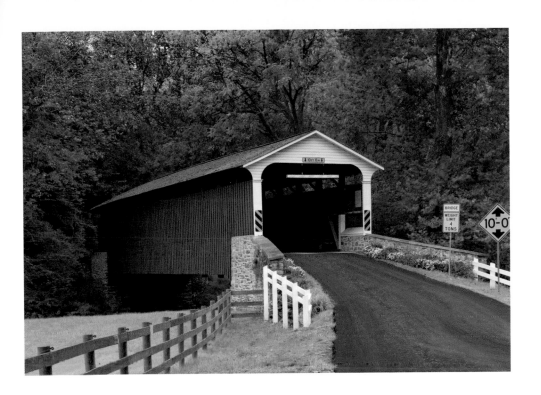

Mercer's Mill Covered Bridge,
Chester/ Lancaster Counties

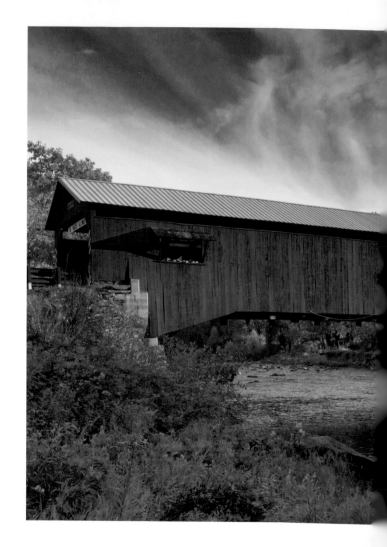

Forksville Covered Bridge,
Sullivan County

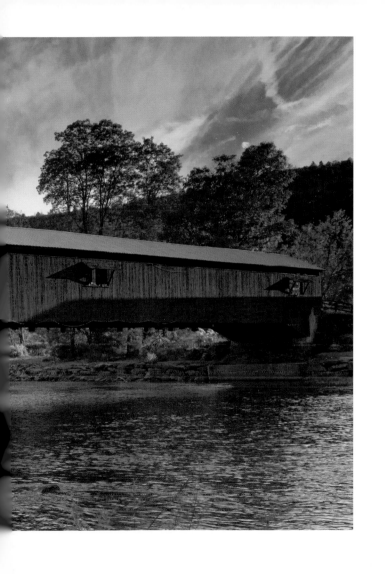

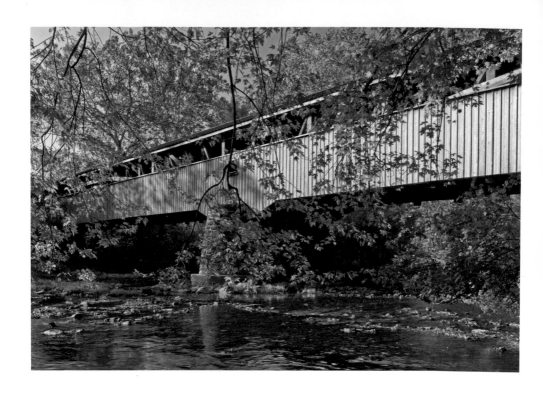

Academia/Pomeroy Covered Bridge,
Juniata County

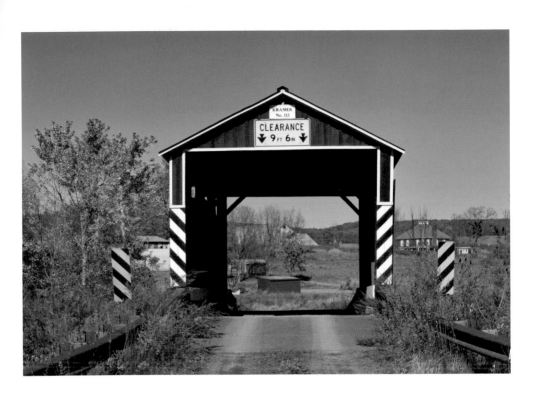

Kramer Covered Bridge,
Columbia County

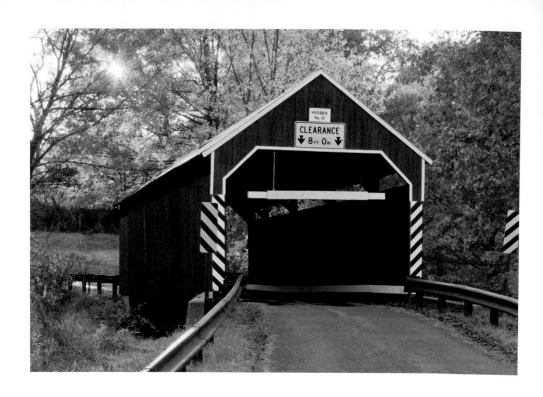

Snyder Covered Bridge,
Columbia County

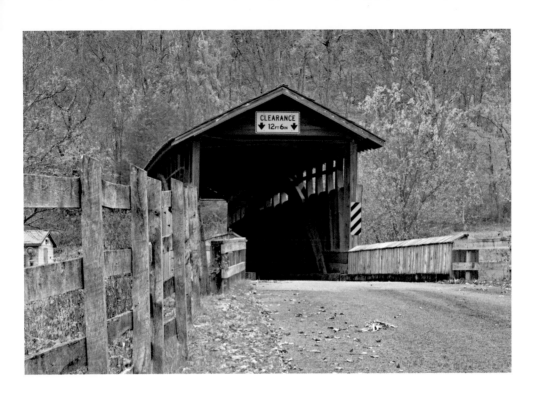

The sign on the bridge reads:

CLEARANCE
↓ 12 FT 6 IN ↓

Claycomb/Reynoldsdale Covered Bridge,
Bedford County

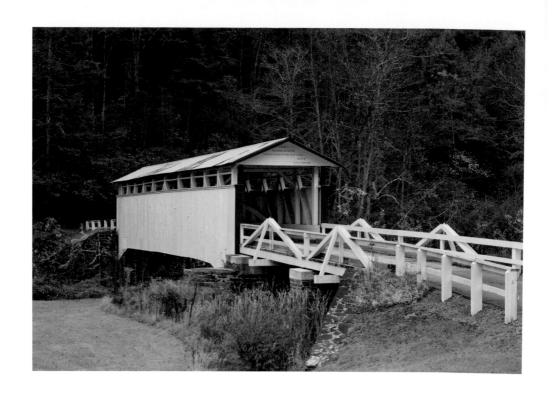

Jackson's Mill/Barnhart's Covered Bridge,
Bedford County

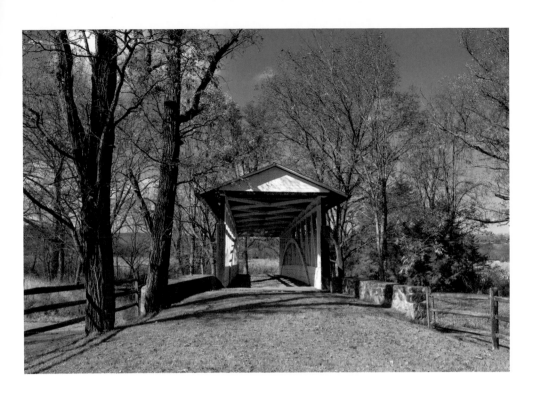

Doctor Knisley Covered Bridge,
Bedford County

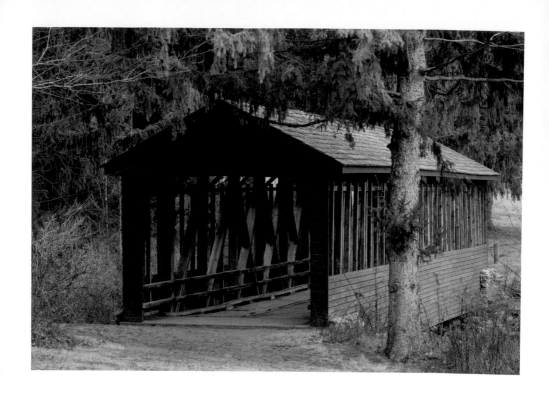

Harrity/Bucks Covered Bridge,
Carbon County

Griesemer's Mill Covered Bridge,
Berks County

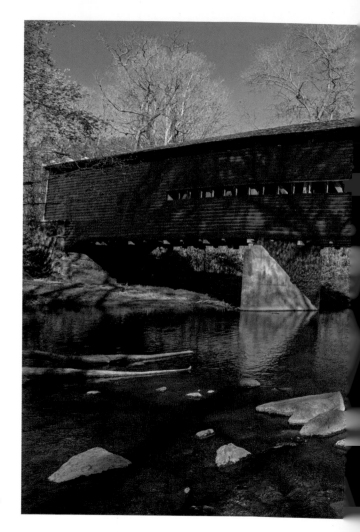

Sheeder's/Halls Covered Bridge,
Chester County

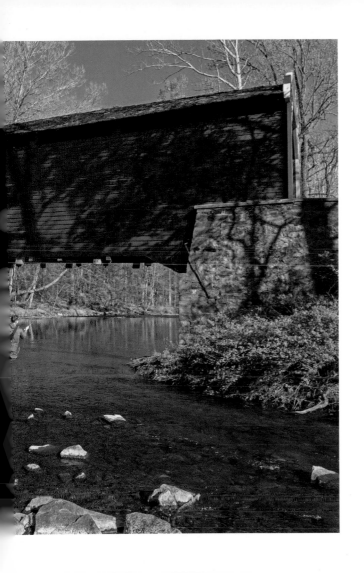

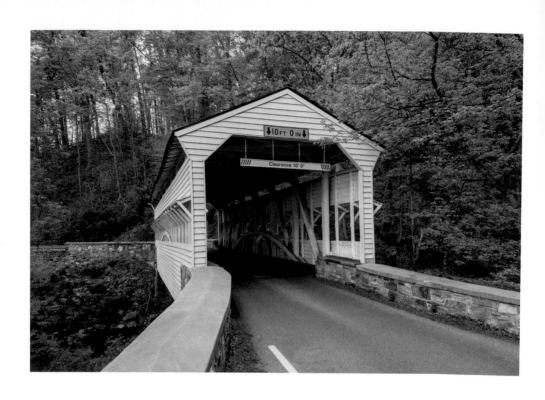

Knox/Valley Forge Covered Bridge,
Chester County

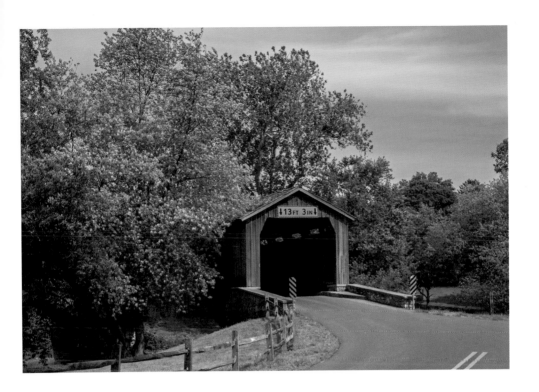

Hunsecker's Mill Bridge,
Lancaster County

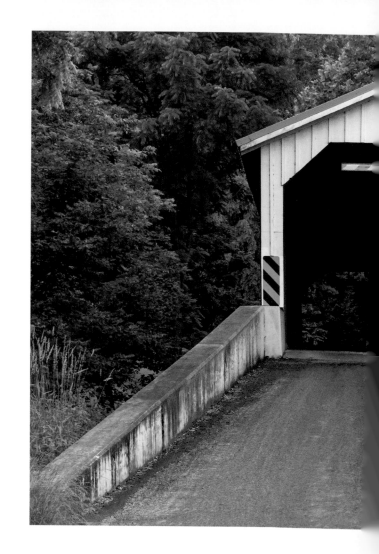

Baumgardner's Mill Bridge,
Lancaster County

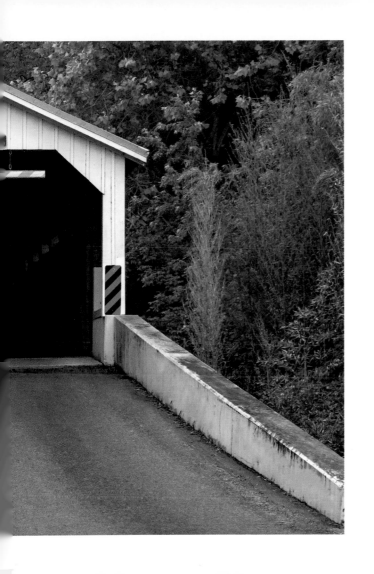

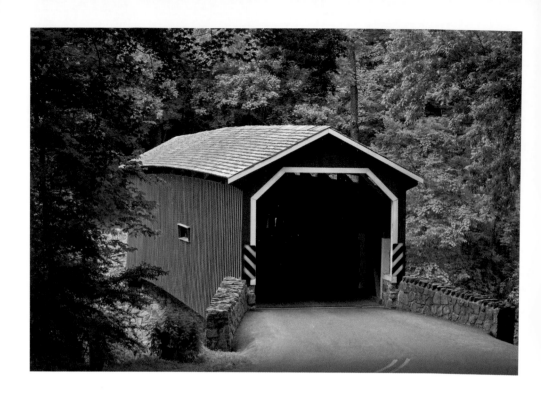

Kurtz's Mill/Bear's Mill Covered Bridge,
Lancaster County

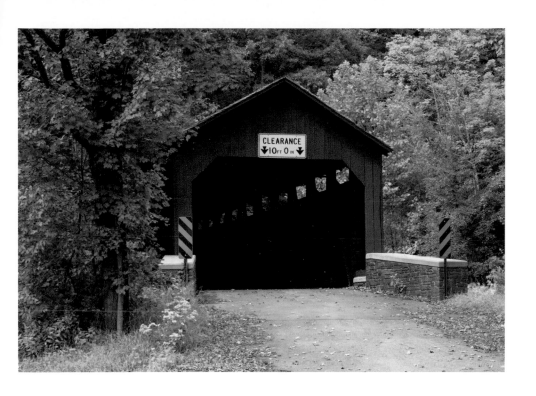

Sonestown/Davidson Covered Bridge,
Sullivan County

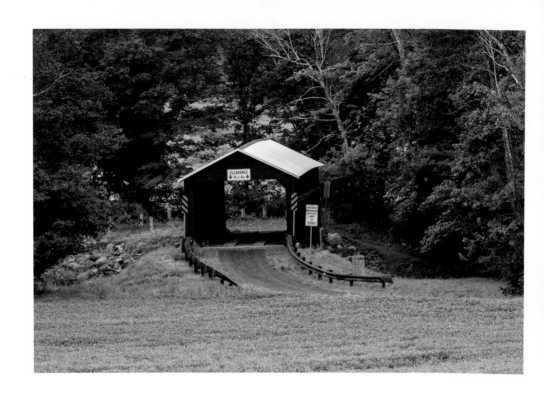

Lairdsville/Moreland/Frazier Covered Bridge,
Lycoming County

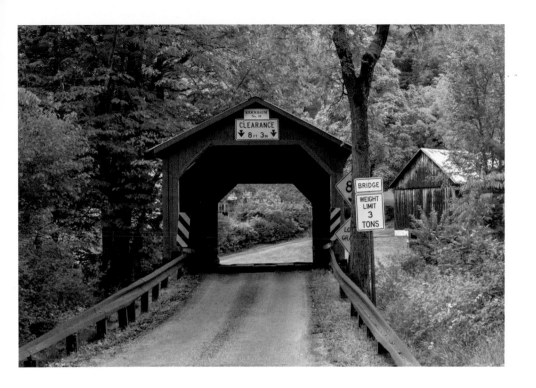

Krickbaum/Kreigbaum Covered Bridge,
Columbia/Northumberland Counties

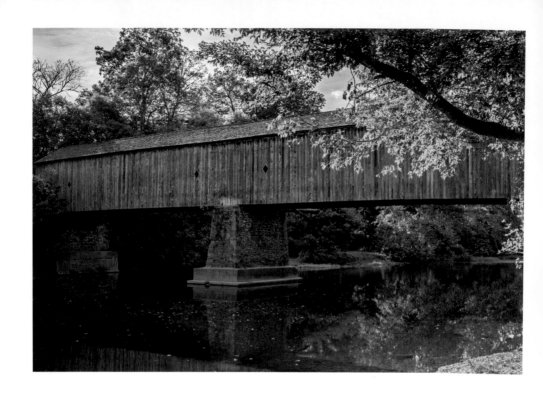

Twining Ford/ Schofield Ford Covered Bridge,
Bucks County

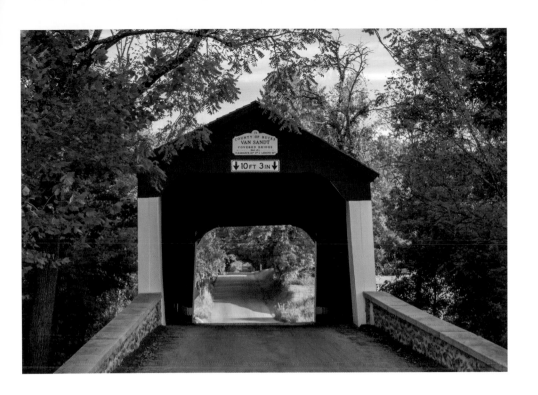

Van Sant /Beaver Dam Covered Bridge,
Bucks County

Bartram's/Goshen/Garrett's/
Sager's Gristmill Covered Bridge,
Chester/Delaware Counties

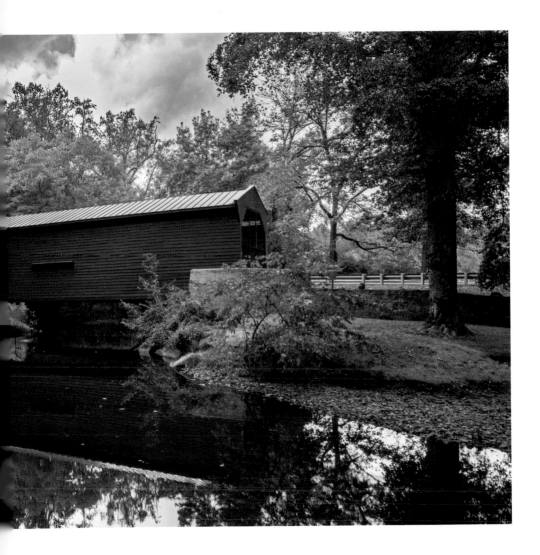

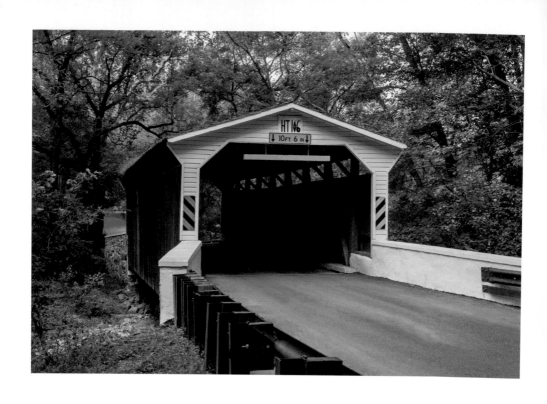

Glen Hope/Elk Mills/Anderson's Ford Covered Bridge,
Chester County

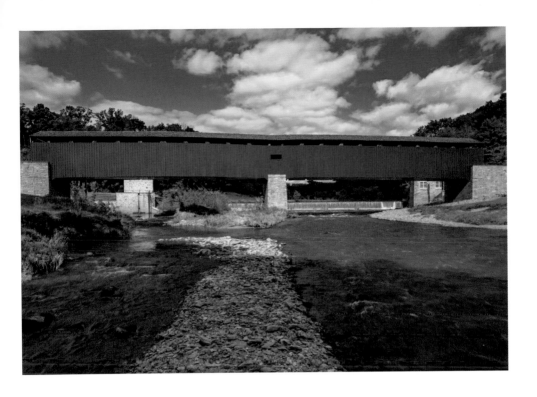

Pine Grove Forge/Little Britain Covered Bridge,
Chester/Lancaster Counties

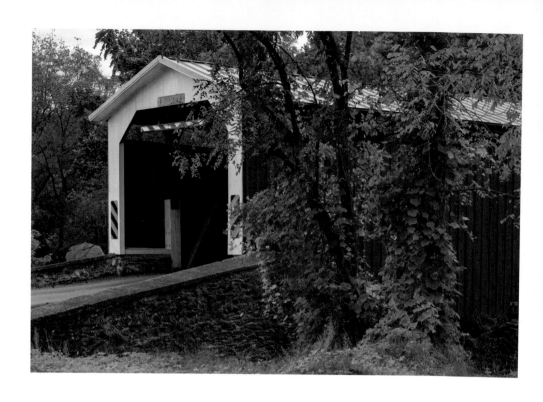

White Rock Forge Covered Bridge,
Lancaster County

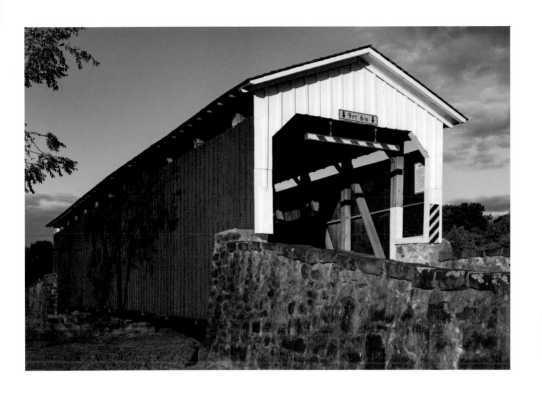

Weaver's Mill/White Hall Covered Bridge,
Lancaster County

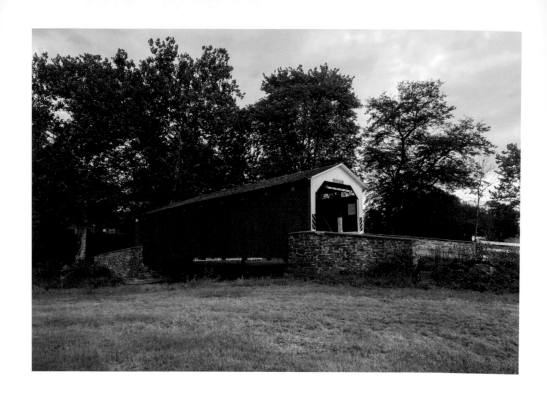

Erb's Covered Bridge,
Lancaster County

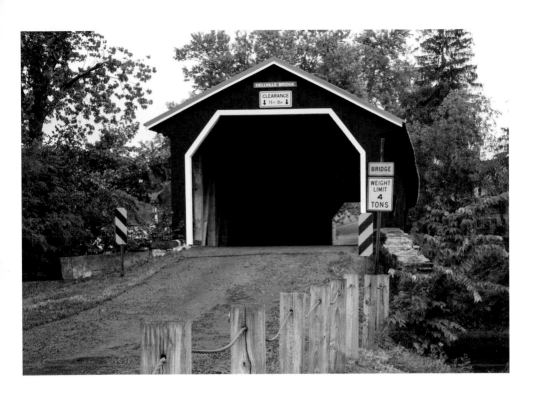

Dellville/Billows Ford Covered Bridge,
Perry County

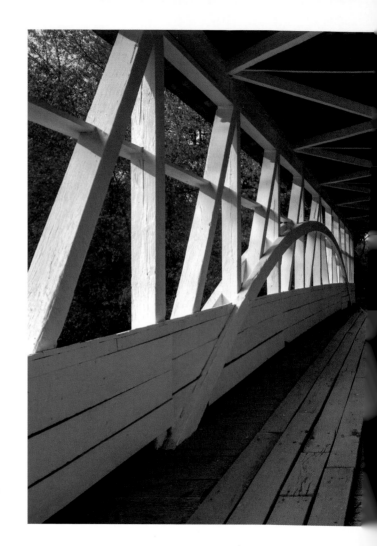

Diehl's/Raystown/Turner's/
Williams Covered Bridge,
Bedford County

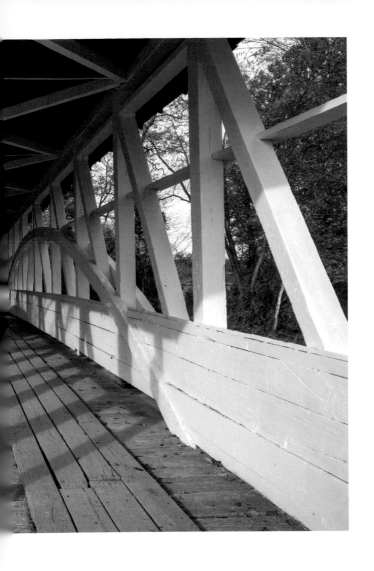

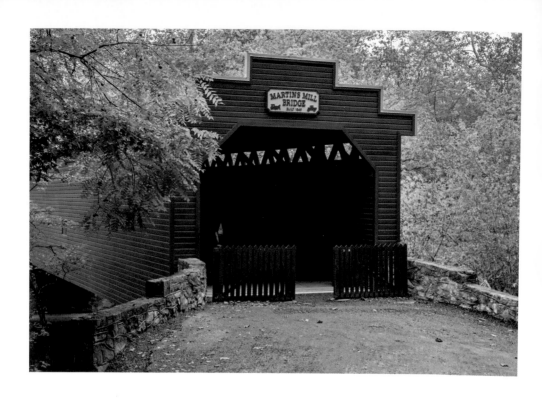

Martin's Mill/Shindle Covered Bridge,
Franklin County

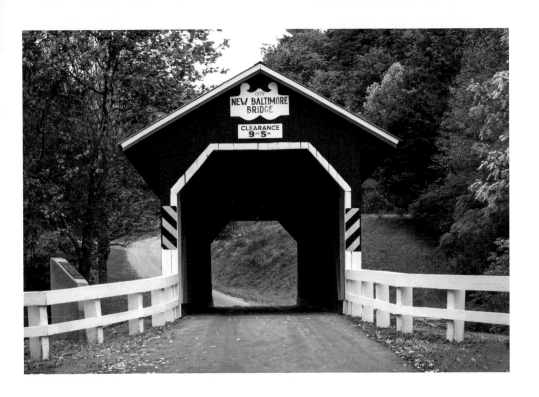

New Baltimore Covered Bridge,
Somerset County

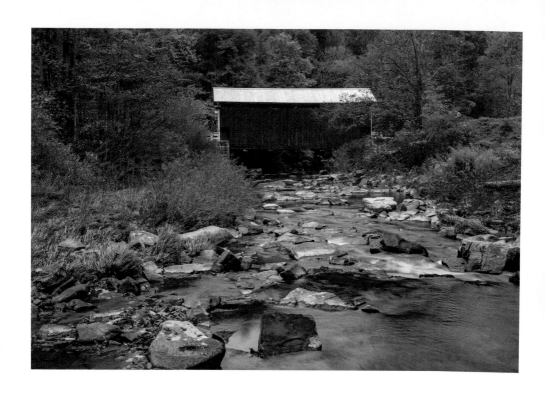

Packsaddle/Doc Miller Covered Bridge,
Somerset County

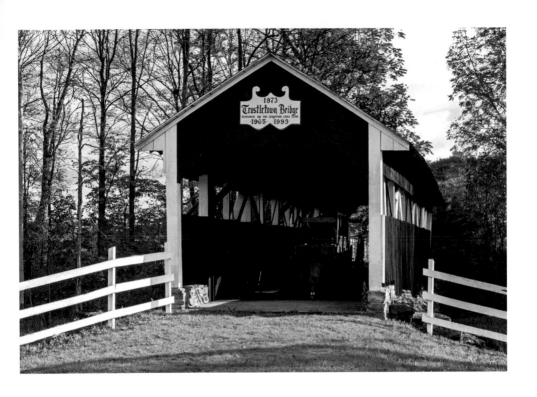

Trostletown/Kantner Covered Bridge,
Somerset County

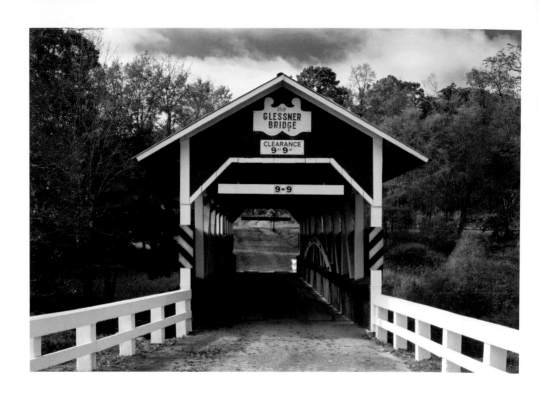

Glessner Covered Bridge,
Somerset County

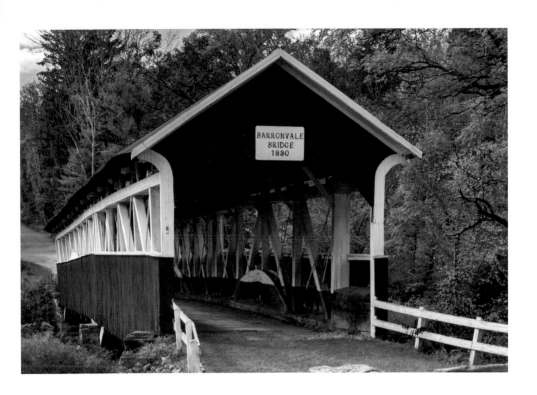

Barronvale Covered Bridge,
Somerset County

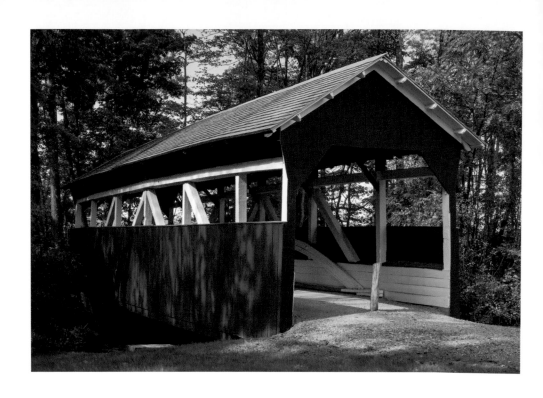

Walter's Mill/Roberts/Cox Creek Covered Bridge,
Somerset County

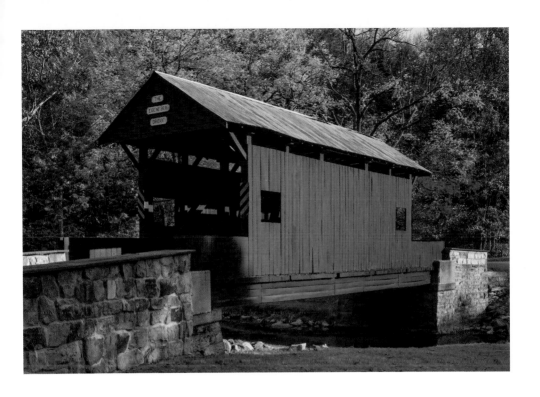

Ebenezer/Ebenezer Church Covered Bridge,
Washington County

Henry Covered Bridge,
Washington County

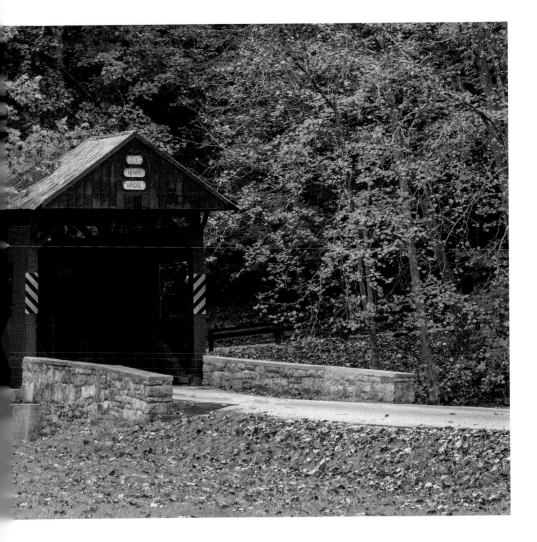

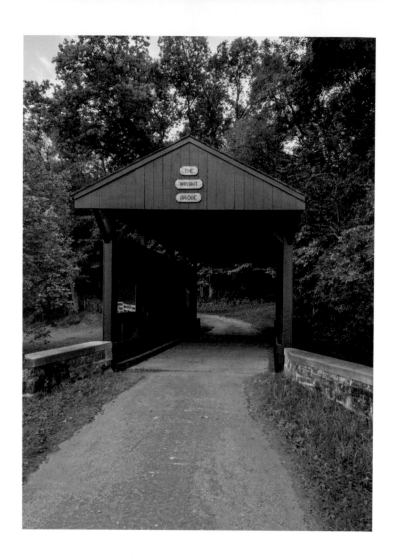

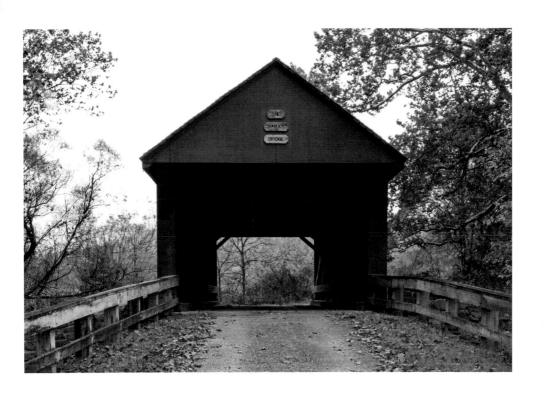

Wright/Cerl/Ceil Covered Bridge,
Washington County

Bailey Covered Bridge,
Washington County

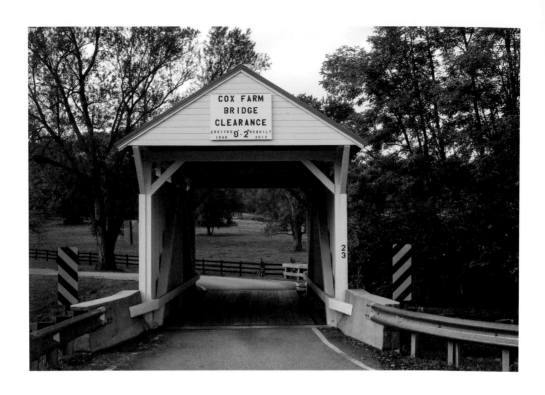

Cox Farm/Lippencott Covered Bridge,
Greene County

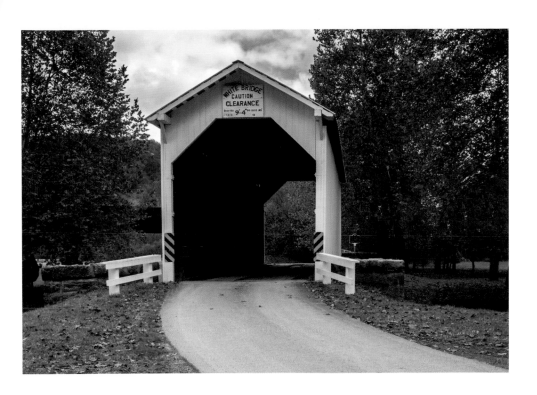

White Covered Bridge,
Greene County

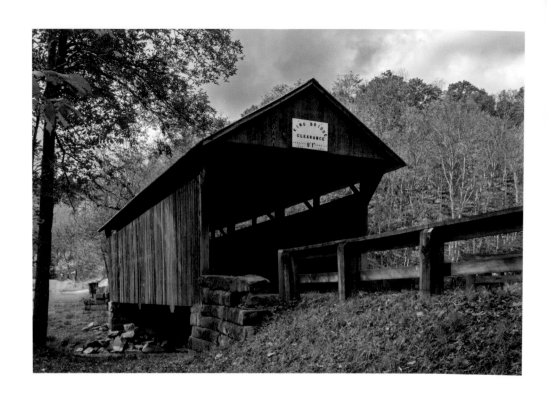

King Covered Bridge,
Greene County

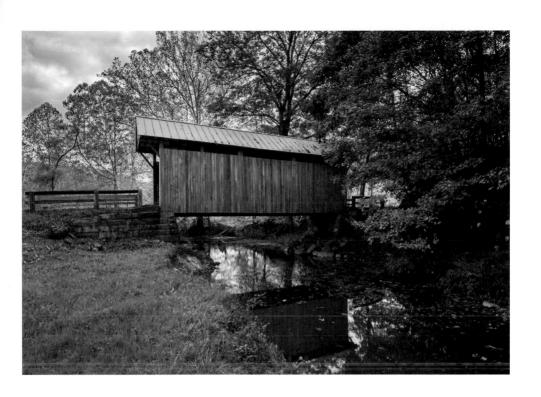

Scott Covered Bridge,
Greene County

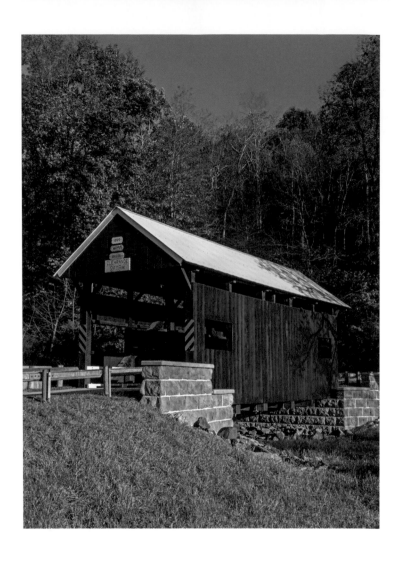

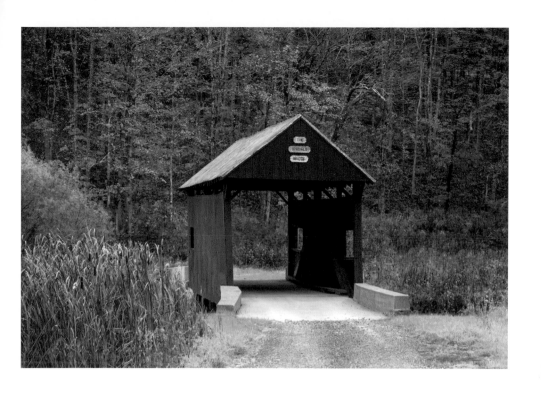

Mays/Blaney Covered Bridge,
Washington County

Sprowl's Covered Bridge,
Washington County

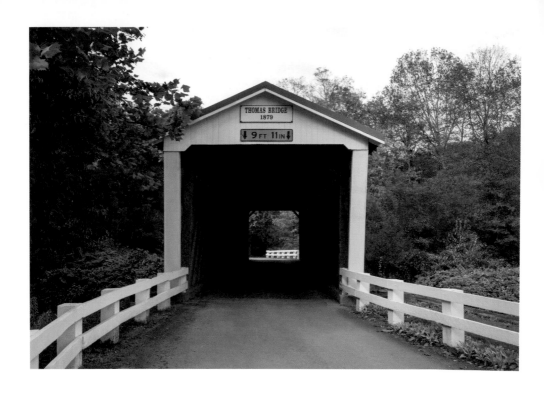

Thomas Ford/Thomas Station Covered Bridge,
Indiana County

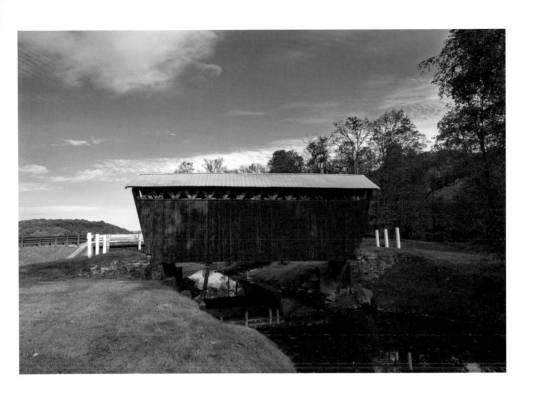

Trusal/Dice Covered Bridge,
Indiana County

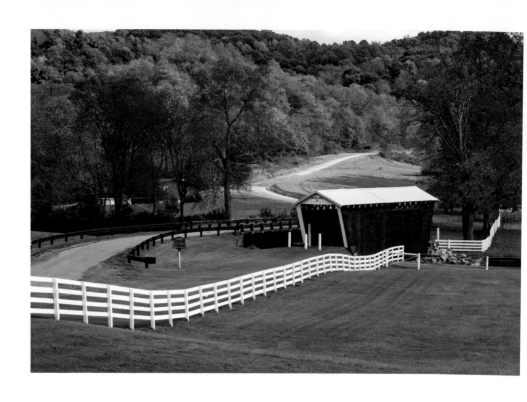

Harmon Covered Bridge,
Indiana County

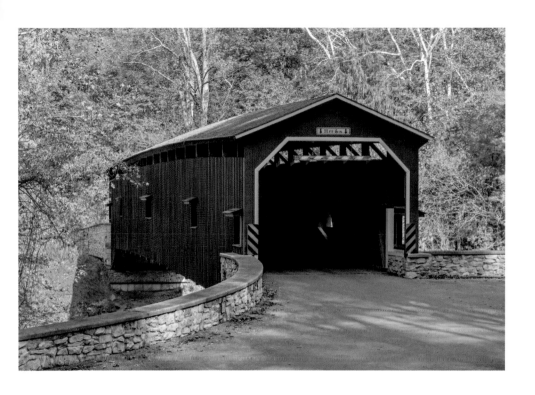

Colemanville/Colemanville Mill Covered Bridge,
Lancaster County

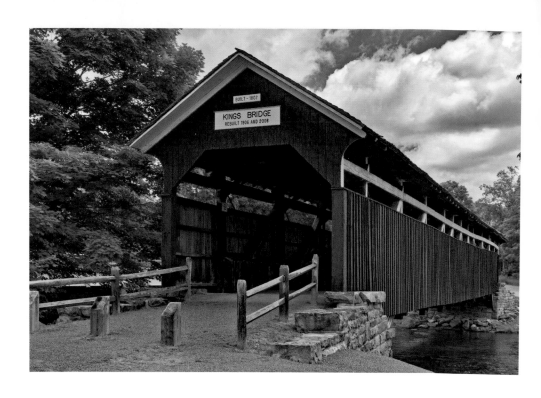

King's Bridge,
Somerset County

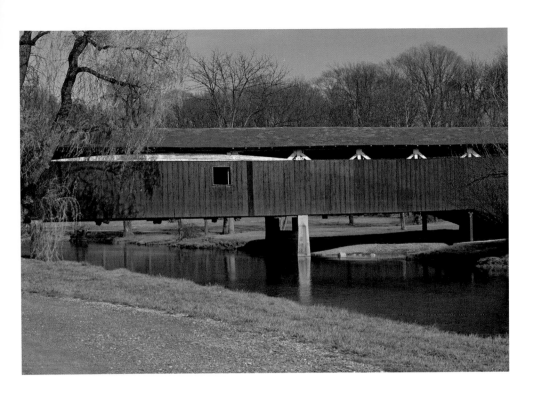

Bogert's Covered Bridge,
Lehigh County

Sachs/Sauck's Covered Bridge,
Adams County

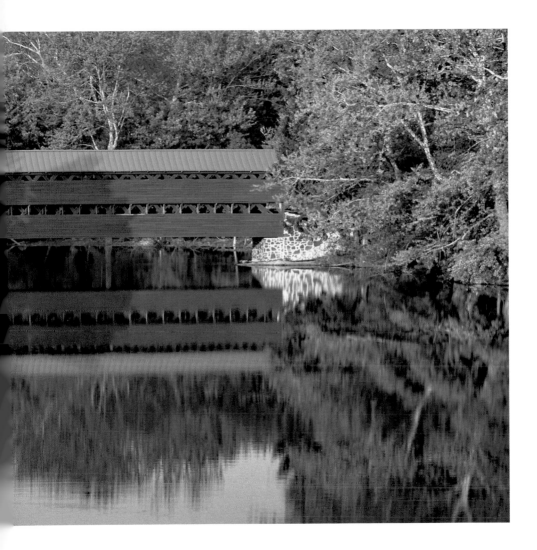

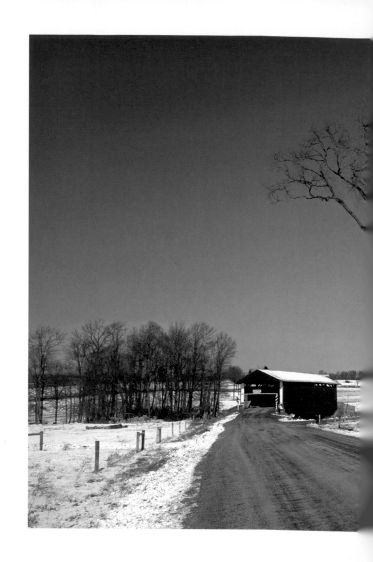

Hayes Covered Bridge,
Union County

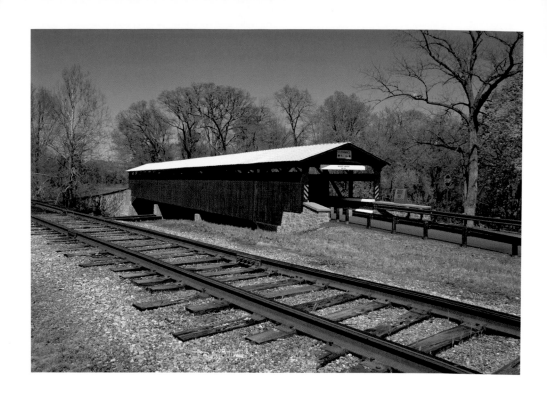

Rupert Covered Bridge,
Columbia County

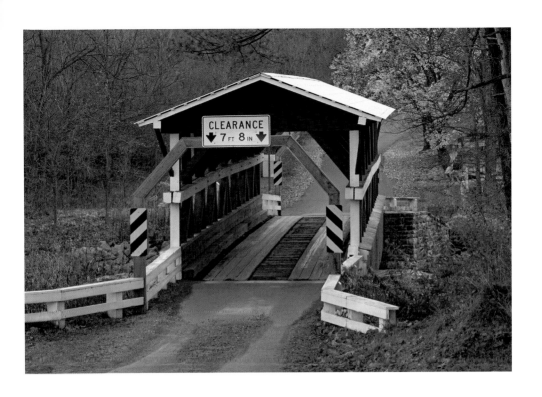

Colvin/Calvin/Shiller Covered Bridge,
Bedford County

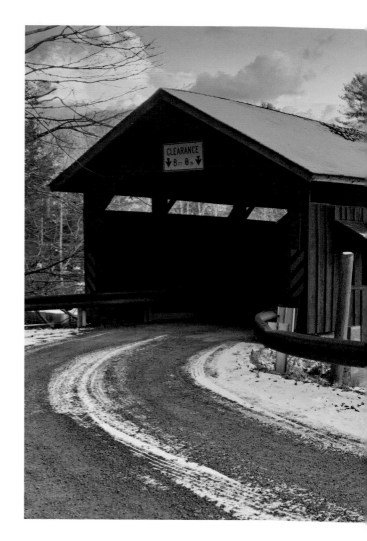

Hillsgrove Covered Bridge,
Sullivan County

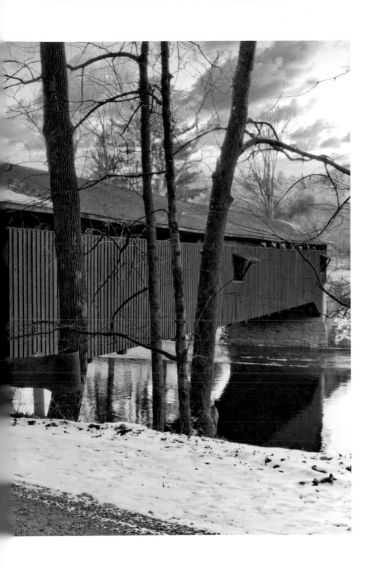

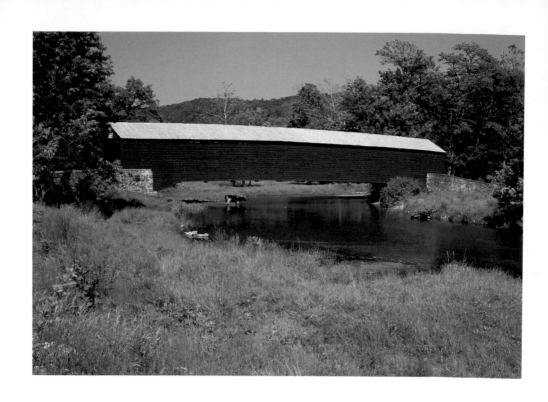

Griesemer's Mill Covered Bridge,
Berks County

***Michael P. Gadomski*** is a third-generation Pennsylvania native. He worked as a Pennsylvania state park ranger and naturalist for more than 25 years and has been a freelance writer and photographer for more than 40 years. His articles have appeared in publications such as the New York State Conservationist and Highlights for Children. His photography has been published worldwide in books, calendars, interpretive displays, and magazines. He is the photographer/writer of nine coffee-table books: *Wild Pennsylvania: A Celebration of Our State's Natural Beauty, Philadelphia: Portrait of a City, The Catskills: A Photographic Portrait, Reserves of Strength: Pennsylvania's Natural Landscape, Pittsburgh: A Renaissance City, The Poconos: Pennsylvania's Mountain Treasure, Pennsylvania: A Portrait of the Keystone State, Scenes from the Country Fair,* and *Delaware Water Gap National Recreation Area.* His website is www.mpgadomski.com.

**Other Schiffer Books by the Author:**
*Philadelphia: A Keepsake, ISBN: 9780764357572*
*Pittsburgh: A Keepsake, ISBN: 9780764357589*

Copyright © 2023 by Michael P. Gadomski

Library of Congress Control Number:
2022946126

Edited by Ian Robertson
Designed by Molly Shields
Type set in BellMT/Cambria

ISBN: 978-0-7643-6604-8
Printed in China

Published by Schiffer Publishing, Ltd.
4880 Lower Valley Road
Atglen, PA 19310
Phone: (610) 593-1777; Fax: (610) 593-2002
Email: Info@schifferbooks.com
Web: www.schifferbooks.com

For our complete selection of fine books on this and related subjects, please visit our website at www.schifferbooks.com. You may also write for a free catalog.

Schiffer Publishing's titles are available at special discounts for bulk purchases for sales promotions or premiums. Special editions, including personalized covers, corporate imprints, and excerpts, can be created in large quantities for special needs. For more information, contact the publisher.

We are always looking for people to write books on new and related subjects. If you have an idea for a book, please contact us at proposals@schifferbooks.com.

FSC
www.fsc.org
MIX
Paper | Supporting responsible forestry
FSC® C104723